Celebrating the
Beauty Within

Celebrating the Beauty Within

A Book for Women

Arlene F. Benedict

Ariel Books

•

**Andrews McMeel
Publishing**

Kansas City

www.andrewsmcmeel.com

ISBN: 0-8362-2654-2

Contents

Introduction

*E*very day we are bombarded with advertisements for things promising to make us unimaginably gorgeous: mascara that lasts through rainstorms, shampoo that makes our hair luminescent. Beauty, we are told, goes hand in hand with physical appearance. And perhaps it does. But there is another component to beauty—one that has nothing to do with flawless skin or stylish haircuts. It is the beauty within ourselves that surfaces when we bring grace, wisdom, and myriad other qualities into our lives.

Inner beauty may be difficult to describe, but we recognize it when we experience it. It is the unmistakable glow of a woman who is comfortable with herself and who loves her life, no matter what it brings. Inner beauty is that intangible "something" that makes us feel renewed and refreshed in the presence of a woman who has it.

Let this elegant volume of quotations and original essays guide you through an exploration of inner beauty, which, unlike our bodies, does not fade with age. Hidden under your outward appearance is a beautiful being waiting to be discovered.

What Is Inner Beauty?

Inner beauty is . . . grace

Within ourselves, we all have the power to soothe the spirits of others. This ability is grace, a hallmark of inner beauty.

The gracious person uses words of forgiveness to repair broken relationships and words of welcome to forge new ones. Surprising someone with a kind deed, a gracious person can warm an icy silence and spark in the other person a willingness to open up. Grace allows us to listen compassionately to another's dreams and beliefs, even when we do not share the same goals or point of view, and to respond with encouragement, sympathy, and respect.

Grace can be expressed with a touch or a look. We can transmit our care and concern by acts as simple as patting a shoulder, giving a hug, or even shaking hands. A sincere smile or an encouraging nod can make all the difference to someone, whether they are in deep pain or merely having a bad day. Treating others with grace makes us more gracious ourselves, and thus we perpetuate this virtue merely by practicing it. And the more we practice it, the more natural being gracious becomes.

Today, I will demonstrate grace by offering a healing word or a soothing touch.

Without grace beauty is an unbaited hook.

—French proverb

•

Grace fills empty spaces, but it can only enter
where there is a void to receive it, and
it is grace itself which makes this void.

—Simone Weil

I would like to achieve a state of inner
spiritual grace from which I could function and
give as I was meant to in the eye of God.

—Anne Morrow Lindbergh

•

I don't believe that one person heals another.
I believe that what we do is invite the other person
into a healing relationship. We heal together.

—Rachel Naomi Remen

Beauty is not caused.
It is.

—Emily Dickinson

•

You can take no credit for beauty at sixteen.
But if you are beautiful at sixty,
it will be your soul's own doing.

—Marie Stopes

*I*nner beauty is . . . *acceptance*

When we accept ourselves, we cast off the masks, disguises, and costumes that we usually hide behind. Taking a long, honest look at ourselves—warts and all—is the first step. Yes, we've gained ten pounds, we're not a gourmet chef, and, okay, we snore. But perfection is a myth—and striving for it is a waste of time. If we spend our time trying to be "perfect" (whatever our definition), we will only be frustrated when we come up short. Sure, we are bound to make lots of blunders in life but instead of berating ourselves, we must simply try again.

Accepting ourselves leaves us with a refreshingly realistic view of our strengths and weaknesses. Acceptance doesn't mean that we never change; but it *does* mean we know what we can reasonably change about ourselves and what we cannot.

Once we have accepted ourselves, we are more accepting of others. Since we no longer expect perfection from ourselves, we no longer demand it of our friends, family, or coworkers. We readily welcome new people into our lives, without judging them by rigid standards. Perhaps in the past, we have let differences in education, accents, or financial status stand in the way of potential friendships. Now, we can accept others with truly open hearts and minds.

Today, I will accept myself for who I am and others for who they are.

To accept what you are is to be content,
and contentment is the greatest wealth.
To work with patience is to gather power.
To surrender to the Eternal flow is
to be completely present.

—Vimalia McClure

•

Don't accept that others know
you better than yourself.

—Sonja Friedman

Until you make peace with who you are,
you'll never be content with what you have.

—Doris Mortman

•

A contented spirit is the sweetness of existence.

—Anonymous

If you can't change your fate, change your attitude.

—Amy Tan

•

I accept the universe!

—Margaret Fuller

*I*nner beauty is . . . serenity

A state of inner calm, serenity comes to us when we maintain a peaceful outlook on life, and thereby create a tranquil environment for ourselves. Serene people are not unrealistic dreamers or those who have only light burdens—indeed, many serene people lead very difficult lives. It is their equanimity and their centeredness and that sets them apart.

Of course, being serene doesn't make us immune from hurt, pain, and anger, but it does make us better able to handle these emotions and not let them overwhelm us. When we are tranquil, we don't sweat the little things, such as flat tires or lines at the bank. Being serene removes tension from our lives; and couldn't we all stand a little less tension? When we're calm and collected, not only do we feel better, but we also become more pleasing to be around.

Leading a serene life means balancing our personal time and our family time; our work and our play. If we hit a snag in one area of our lives, we glean satisfaction from another. Like everything worthwhile, becoming centered and serene takes patience and effort. But the results will be lasting—and wonderful!

Today, I will have a balanced outlook on my life.

Believing in our hearts that who we are is
enough is the key to a more satisfying and balanced life.

—Ellen Sue Stern

●

I am a woman who enjoys herself very much;
sometimes I lose, sometimes I win.

—Mata Hari

The person who has not learned to be happy and
content while completely alone for an hour, a day,
or a week has missed life's greatest serenity.

—H. Clay Tate

•

I think these difficult times have helped me to understand
better than before how infinitely rich and beautiful life is in
every way and that so many things that one goes around
worrying about are of no importance whatsoever.

—Isak Dinesen

Goodness is uneventful. It does not flash, it glows.

—David Grayson

•

I'm a believer in God and the ultimate goodness.

—Marian Anderson

*I*nner beauty is . . . *wisdom*

Remember being in kindergarten and looking up to the third-graders, thinking that they knew everything; and then in third grade, we thought the sixth-graders were so smart? As children, we believed that the older and more educated we got, the wiser we would become. Perhaps we still feel this way to some degree, looking to our elders, professors, the clergy, or family members for pearls of wisdom. And while these people can be wonderful sources of wisdom, wisdom is not necessarily a by-product of age or education. It is a profound knowledge and deep understanding of human nature and life.

From prayer and meditation, from our feelings and experiences, we gain wisdom. No matter where we are or what we do, there are things to be learned every day. When we learn these lessons, and take the time to reflect upon what we have learned, we grow wiser.

Part gift and part practice, wisdom is a trait we can develop in ourselves. Wisdom does not come overnight, and it comes in different ways to each of us, but if we scratch beneath the surface of life to discover what truths lie there, it does come.

Today, I will seek wisdom from others but especially from within myself.

There are two ways of spreading light: to be
The candle or the mirror that receives it.

—Edith Wharton

•

There comes a moment in life when moral beauty seems more urgent,
more penetrating, than intellectual beauty; when all that the mind
has treasured must be bathed in the greatness of soul, lest it perish in the
sandy desert, forlorn as the river that seeks in vain for the sea.

—Maurice Maeterlinck

What matters most is that we learn from living.

—Doris Lessing

•

The soul is the aspect of ourselves that is specific
of our nature and distinguishes man from all
other animals. We are not capable of defining this
familiar and profoundly mysterious entity.

—Alexis Carrel

•

Learning to live with what you're born
with is the process, the involvement,
the making of a life.

—Diane Wakoski

Inner beauty is . . . compassion

Using the power of compassion, we reach out, assist, and support those in need. Compassion is a force that breathes hope into the despairing and instills strength into the weary. Those touched by compassion radiate the glow of the warmth that has enveloped them.

When we show compassion, we extend sympathy to the hurt and empathy to the betrayed; we show tenderness to the rough and tolerance to the rude. We comfort. As compassionate people, we are attuned to the suffering around us, ready to help others when we can.

Being compassionate requires that we temporarily set aside our own needs to care for someone whose pain or fear requires immediate attention. Though we may think that we don't have the time or energy to help others, we often find instead that our strength is not drained by our efforts but is, in fact, renewed by them. Our acts of compassion uplift not only those we help, but ourselves as well. Compassion strengthens the human race using one simple tool: tender loving care. It is the best way to bring out the divine in all of us.

Today, I will be compassionate to those in need.

She did not talk to people as if they were strange hard shells she had to crack open to get inside. She talked as if she were already in the shell. In their very shell.

—Marita Bonner

•

Being unwanted, unloved, uncared for, forgotten by everybody, I think that is a much greater hunger, a much greater poverty than the person who has nothing to eat. . . . We must find each other.

—Mother Teresa

Spiritual energy brings compassion into the real world.
With compassion, we see benevolently our own human
condition and the condition of our fellow beings.
We drop prejudice. We withhold judgment.

—Christina Baldwin

•

Compassion for myself is the most
powerful healer of them all.

—Theodore Isaac Rubin

Neither genius, fame, nor love show the greatness
of the soul. Only kindness can do that.

—Jean-Baptiste-Henri Lacordaire

•

If the world seems cold to you,
kindle fires to warm it.

—Lucy Larcom

*I*nner beauty personified: Mother Teresa of Calcutta

Her skin is weathered and wrinkled by the sun, and her five-foot stature appears fragile, but Mother Teresa truly is radiant. In the face of this tiny nun, we see the countenance of someone whose life embodies compassion, grace, serenity, and acceptance.

Her beliefs are simple: All humans deserve to be loved, to live in decent conditions, and to die with dignity. Extending her compassion to all people without judgment or condemnation, she has founded schools, homes, and hospitals where before only slums and decay existed.

Her sister nuns are taught to respond with grace and equanimity to every person and every situation. With complete acceptance they minister lovingly to lepers or AIDS patients; with serenity they carry out their work in the midst of political strife or monsoon rains; with grace, they comfort and care for some of the most impoverished people in the world.

Must we move to Calcutta to show compassion? Of course not. We too can practice acceptance and grace right here, right now. And we can live our lives in such a way that we bring hope and joy to the faces of our fellow beings. The beauty of our compassion, the warmth of our serenity, and the kindness of our actions will uplift all the people we touch.

Today, I will bring compassion, grace, serenity, and acceptance to the people in my family and my neighborhood.

Good deeds are better than wise sayings.

—Talmud

•

We can do no great things—
only small things with great love.

—Mother Teresa

If I can stop one Heart from breaking
I shall not live in vain
If I can ease one Life the Aching
Or cool one Pain
Or help one fainting Robin
Unto his Nest again
I shall not live in Vain.

—Emily Dickinson

•

The way to make yourself pleasing to others is to
show that you care for them. . . . The seeds of love
can never grow but under the warm and genial
influence of kind feelings and affectionate manners.

—William Wirt

The love of our neighbor in all its fullness
simply means being able to say to him,
"What are you going through?"

—Simone Weil

●

Let us no more contend, nor blame
Each other, blam'd enough elsewhere, but strive
In offices of love, how we may lighten
Each other's burden, in our share of woe.

—John Milton

Gaining Inner Beauty

Find your passion and make room for it in your life

Much of life is routine: We wake up at the same time every day, we run the same errands week after week, we hold the same job for years. It is by cultivating our talents and interests in ways that give us pleasure that we imbue our lives with vitality and passion. We breathe life into our lives.

Time spent on our interests is for ourselves—no one else. If we are crazy about flowers, we can plant a garden, or even a window box. If we adore old movies, we may take a film class at a local college. When we discover, and then pursue, what we love, we give our spirits a boost. What does it matter that no one else quite appreciates our passion for collecting ceramic cookie jars? We love them.

Maybe, at first, it seems frivolous to spend time on hobbies. During our pottery class, we may find ourselves thinking of the laundry that needs to be done or the project at work that needs more effort. But it is okay—it is essential—to do things for ourselves, and we shouldn't feel selfish for doing them. Doing what we want, if only for a few hours a week, makes us happy. The same cannot always be said for doing the laundry.

Today, I will recognize my interests and talents and do something with them.

Follow your bliss.

—Joseph Campbell

•

Far away there in the sunshine are my highest aspirations.
I may not reach them but I can look up and see their beauty,
believe in them, and try to follow where they lead.

—Louisa May Alcott

•

We have to dare to be ourselves, however
frightening or strange that self may prove to be.

—May Sarton

What really matters is what you do with what you have.

—Shirley Lord

•

We are not sent into this world to do anything
into which we cannot put our hearts.

—John Ruskin

•

The soul should always stand ajar,
ready to welcome the ecstatic experience.

—Emily Dickinson

Treat others with kindness

Unexpected but simple acts of kindness surprise and uplift us. We're stuck in traffic, sure that we'll never make that left turn, when suddenly a stranger waves us on and lets us go ahead of him. Little gestures like these can make our day.

Practicing kindness means taking one extra second (really!) to think about what we're doing. Instead of ridiculing a friend, we can hold our tongues and avoid unnecessary embarrassment and hurt. Rather than repeating a rumor about a colleague, we can give praise instead. We needn't scold our children in front of company; correcting them in private works just as well and prevents them from feeling ashamed.

It is important to treat ourselves kindly also. We do so by not criticizing or demeaning ourselves, in word or deed, and by refusing to accept abuse from others. Preventing hurt feelings and bruised egos (including our own), is what kindness is all about. Simply put, kindness improves the quality of all our lives.

Today, I will put kindness into my life and the lives of those around me.

What do we live for, if it is not to make
life less difficult for each other?

—George Eliot

•

Kindness can become its own motive.
We are made kind by being kind.

—Eric Hoffer

•

One kind word can warm three winter months.

—Japanese proverb

•

No act of kindness, no matter how small, is ever wasted.

—Aesop

It is not what we see and touch or that which others do for us
which makes us happy; it is that which we think and feel and do,
first for the other fellow and then for ourselves.

—Helen Keller

•

Never lose a chance of saying a kind word.

—William Makepeace Thackeray

•

Let us make one point . . . that we meet each other
with a smile, when it is difficult to smile. . . . Smile at each
other, make time for each other in your family.

—Mother Teresa

Respect others even if they do not respect you

It is a basic fact of life that there will be people with whom, for one reason or another, we will find it difficult to get along. What can we do about this? We can treat them with respect, and thereby acknowledge their potential to become our friends and allies.

Everyone has good qualities—qualities that are admirable and worthy of respect. If we see only negative traits, it can be impossible to recognize the positive ones. By refusing to focus on the negative, we may find that the good qualities come to the surface, and, simultaneously, our respect for them rises as well. The goal is to extend respect to everyone, not just to our circle of family, friends, and colleagues.

Treated with respect, people will respond in kind. That's the power of respect.

Today, I will extend respect to someone who may not respect me.

Be good to yourself,
Be excellent to others, and
Do everything with love.

—John Wolf

•

If someone listens, or stretches out a hand,
or whispers a kind word of encouragement,
or attempts to understand a lonely person,
extraordinary things begin to happen.

—Loretta Girzartis

Women have a way of treating people more softly.
We treat souls with kid gloves.

—Shirley Caesar

•

Forgiveness is not an occasional act;
it is a permanent attitude.

—Martin Luther King Jr.

As a woman, I have no country. . . .
As a woman my country is the whole world.

—Virginia Woolf

•

Believe all the good you can of everyone.
Do not measure others by yourself.
If they have advantages which you have not,
let your liberality keep pace with their good fortune.
Envy no one, and you need envy no one.

—William Hazlitt

Let a smile reflect the beauty of your soul

Few sights are as lovely as a smile. Smiles beckon, tell, tease without words; they express faith, joy, love, and mischief. We learn to smile as babies—and it is as important an accomplishment as taking our first steps. "Oh, look," our mother or father says, "the baby is smiling a real smile." We use smiles to express pleasure at first; our sense of humor develops later.

And how important our sense of humor proves to be—life would be bleak indeed without it. We reveal our personalities through what tickles our funny bones. Appreciating life's follies, sharing jokes with friends, and, of course, laughing at ourselves are the great joys of humor. If we took ourselves seriously all the time, we would be quite uptight indeed. The people we choose to be friends with usually share our sense of humor; in fact, if we can laugh together, we can probably get through anything together.

Smiling lifts our moods and clears our minds; laughter brightens our days. Perhaps a sense of humor is reason enough to celebrate being alive.

Today, I will share my smile and laughter with others.

A day is lost if one has not laughed.

—French saying

•

Laugh at yourself first, before anyone else can.

—Elsa Maxwell

•

Humor brings insight and tolerance.

—Agnes Repplier

There is, above all, the laughter that comes from the
eternal joy of creation, the joy of making the world new,
the joy of expressing the inner riches of the soul—
laughter from triumphs over pain and hardship in the
passion for an enduring ideal, the joy of bringing the light
of happiness, of truth and beauty into a dark world.
This is divine laughter par excellence.

—John Elof Boodin

•

Laughter can be more satisfying than honor;
more precious than money; more heart-cleansing than prayer.

—Harriet Rochlin

Inner beauty personified: Maria Montessori

At the turn of the twentieth century, when education was based on discipline and classical traditions, one woman radically challenged the notion of childhood education, letting her own inner strengths guide the way. Maria Montessori approached learning in an innovative and creative fashion: She let her students' natural curiosity determine the speed and course of their individual progress.

A woman who genuinely loved and respected children, Maria knew that all of her students had strengths, and encouraged the children to develop them. Not understanding something on the first try was never cause for punishment or ridicule; students were always allowed to try again and again. Taught to believe in themselves and to trust their instincts, students became their own teachers, and the love of learning that they developed during these years sustained them throughout their lives.

Maria Montessori breathed life into her passions and dreams. Since her convictions ran counter to the existing educational system, she created a new one. Full of ideas, she wasn't timid about acting upon them. The joy and dauntless courage that she exhibited inspired educators around the world to follow her example. And, it produced children who loved school, and more important, who loved learning.

Today, I will follow my instincts and beliefs, even if they contradict the practices around me.

You gain strength, courage, and confidence by every
experience in which you really stop to look fear in the face. . . .
You must do the thing you think you cannot do.

—Eleanor Roosevelt

•

Do all the good you can,
By all the means you can,
In all the ways you can,
In all the places you can,
At all the times you can,
To all the people you can,
As long as ever you can.

—John Wesley

The smallest actual good is better than the most
magnificent promises of impossibilities.

—T. B. Macaulay

•

Great thoughts speak only to the thoughtful mind,
but great actions speak to all mankind.

—Emily P. Bissell

Don't be afraid of the space between your dreams and reality.
If you can dream it, you can make it so.

—Belva Davis

•

Find the seed at the bottom of your heart
and bring forth a flower.

—Shigenori Kameoka

•

The text of this book
was set in Bembo and Isadora
by Sally McElwain.

•